Painting with Acrylics

WENDY JELBERT

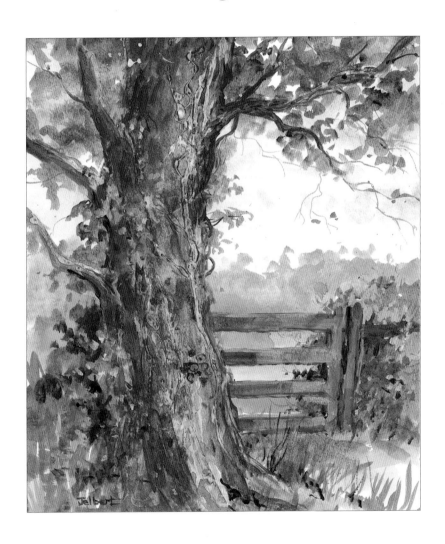

SEARCH PRESS

First published in Great Britain 2000

Search Press Limited
Wellwood, North Farm Road,
Tunbridge Wells, Kent TN2 3DR

Reprinted 2000, 2001

ISBN 0 85532 840 1

The publishers and author can accept no responsibility for any
consequences arising from the information, advice or instructions
given in this publication.

The publishers would like to thank Winsor & Newton for
supplying many of the materials used in this book.

Suppliers
If you have difficulty in obtaining any of the materials and
equipment mentioned in this book, then please write to the
Publishers at the address above, for a current list of stockists,
including firms who operate a mail-order service. Alternatively,
write to Winsor & Newton requesting a list of distributers.

Winsor & Newton, UK Marketing
Whitefriars Avenue, Harrow, Middlesex HA3 5RH

Publisher's note

All the step-by-step photographs in this book feature the
author, Wendy Jelbert, demonstrating how to paint with
acrylics. No models have been used.

Page 1
Garden Gate
165 x 205mm (6½ x 8in)

Page 3
The Old Tree
245 x 285mm (9¾ x 11¼in)

Opposite
Wisteria Bus Stop
175 x 305mm (6¾ x 12in)

Colour separation by Graphics '91 Pte Ltd, Singapore
Printed in Spain by Elkar S. Coop. 48180 Loiu (Bizkaia)

Painting with Acrylics

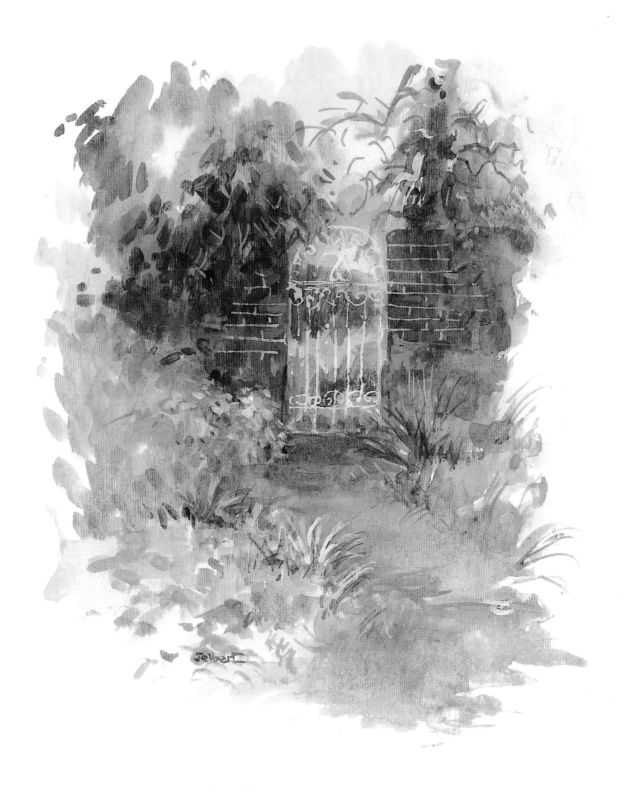

I dedicate this book to my four precious grandchildren –
Georgie Carr, Ella Walker, William Hewetson-Brown, Hugo Walker and
Oliver Hewetson-Brown.

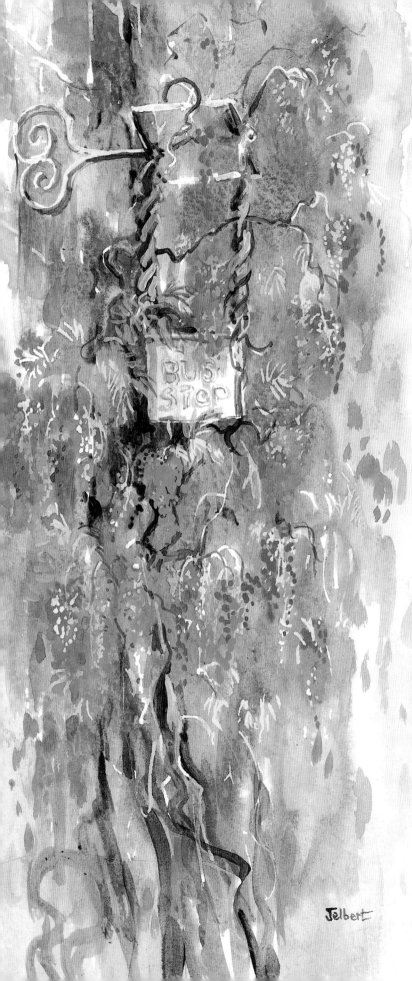

Contents

Introduction 6

Materials 8
*My palette • Paints • Papers
Drawing board • Brushes
Other items*

Colour mixing 12

Playing with acrylics 14
*Watercolour techniques
Oil techniques
Other techniques*

Painting skies 20
*Simple sky – graded wash
Sunset – wet into wet
Stormy sky – oil technique*

Daisies on a cliff top 24
Step-by-step demonstration

Sunlit window 32
Step-by-step demonstration

Farmyard 42
Step-by-step demonstration

Index 48

Introduction

Synthetic binders were discovered as painting mediums during the 1920s. Mexican muralists decided they needed an alternative to fresco and oil painting – they wanted a quick-drying paint which was unaffected by climatic changes. An ideal agent, which was already being used for moulded-plastic items, was discovered and when this was added to the paint it created all the qualities that the artists were seeking – a paint with fast-drying qualities, and with a freshness and permanence that made it suitable for murals and public buildings. Actual acrylic paints were first used in America in the 1950s by colour field artists such as Morris Louis.

Acrylics are amazingly versatile. Watercolour and oil techniques can be used with this remarkable medium, as well as pure acrylic techniques which are exciting and open up all sorts of creative possibilities – you can even mix all the techniques together in one painting. With practice, a vibrancy and spontaneity can be achieved that will inspire you to experiment even further.

Other advantages are that acrylics can be used on a wide range of surfaces – canvas, paper, wood, metal and plaster – and their fast-drying qualities allow colours to be applied quickly without disturbing the layers beneath.

I have taught painting in all media for twenty-five years and acrylics have not always been popular with my students. They have complained about the fast-drying qualities and the brightness of the colours. Slow workers have not always been able to achieve the effects they wanted. However, there are now special palettes available which keep the paints moist, and you can add acrylic mediums to the paints, which retard the drying time so that you can blend and manipulate the colours as you work.

In this book my aim is to demonstrate the versatility and exciting qualities of acrylics, showing how they are a medium of comparative freedom and not one of limitations. Step-by-step demonstrations guide you through all the techniques, and a series of paintings illustrate the points I make. So, if you are a beginner – or if you are rediscovering acrylics for a second time – I hope you will find inspiration in the following pages and that you will soon be painting pictures you are proud of.

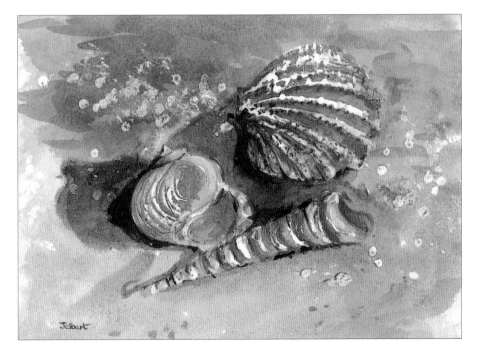

Shells
205 x 155mm (8 x 6in)
These shells had lots of surface texture, and I used the exciting impasto technique (see page 16) to recreate this on the paper.

Opposite
Sea Shore
180 x 245mm (7 x 9¾in)
This simple seascape shows how effective a striking contrast of colour can be. Here, the blues (painted as simple graded washes in the sea areas) work well against the tones of yellow ochre and burnt sienna.

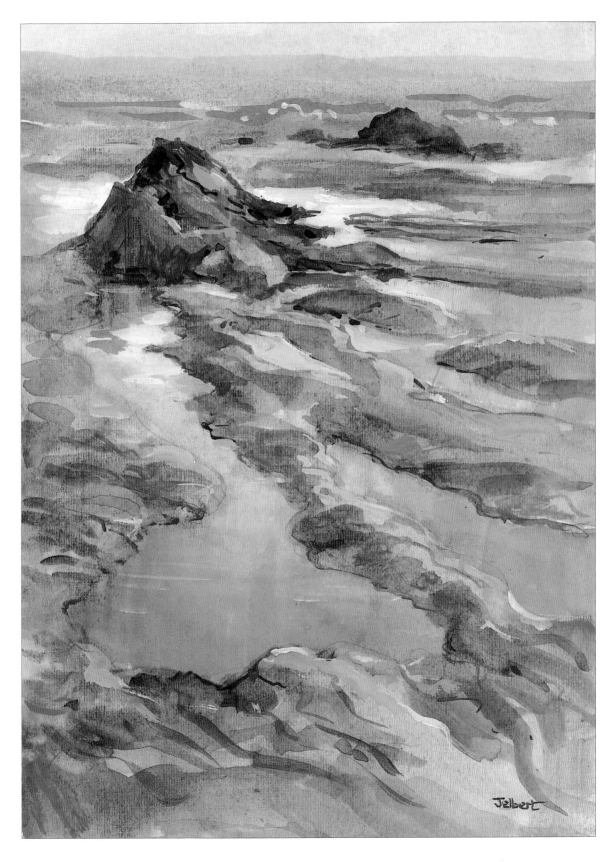

Materials

When choosing paints, brushes and other materials, always buy the best you can afford. Artists' quality colours, for example, are much purer and stronger than lesser qualities and, over a period of time, they will prove more economical to use. In addition to the materials shown on the following pages, I also use a small folding stool and a rucksack when painting on location.

My palette

A palette is an essential part of any artist's equipment. To start with, you could use any deep-welled object as a palette – an old plate or bowl, for example, would be ideal. However, dried-out acrylic paints cannot be reworked and are difficult to remove, so it is essential that they be kept moist throughout a painting session. Most art shops stock stay-wet palettes that are designed specifically for use with acrylics.

Stay-wet palettes usually have a large mixing area, compartments for brushes and a few paints, and a see-through lid that must be replaced at the end of each painting session. Wetted absorbent paper is placed in the mixing area and a sheet of grease-proof or tracing paper is placed on top. Colours are mixed on the grease-proof paper which is replaced from time to time as it gets covered with paint.

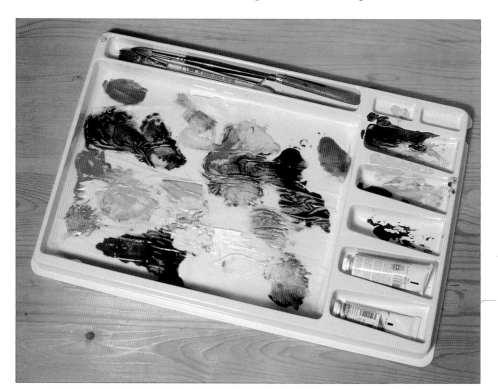

My stay-wet palette with some of my favourite colours. These include:

Lemon yellow
Azo yellow medium
Napthol red light
Permanent alizarin crimson
Ultramarine blue
Phthalo blue (red shade)
Cerulean blue
Olive green
Phthalo green (blue shade)
Yellow ochre
Raw umber
Titanium white
Burnt sienna
Dioxazine purple
Benzimidazolone maroon

My sketchbook

My sketchbook goes with me everywhere and I use it to capture the atmosphere of scenes *in situ*. I plan out future paintings with several preliminary working sketches. I find it fun to experiment with various alternatives – ink or pencil sketches, quick colourful tryouts and variations-on-a-theme. Planning in this way is most important, as it can avoid mistakes that might otherwise occur back in the studio.

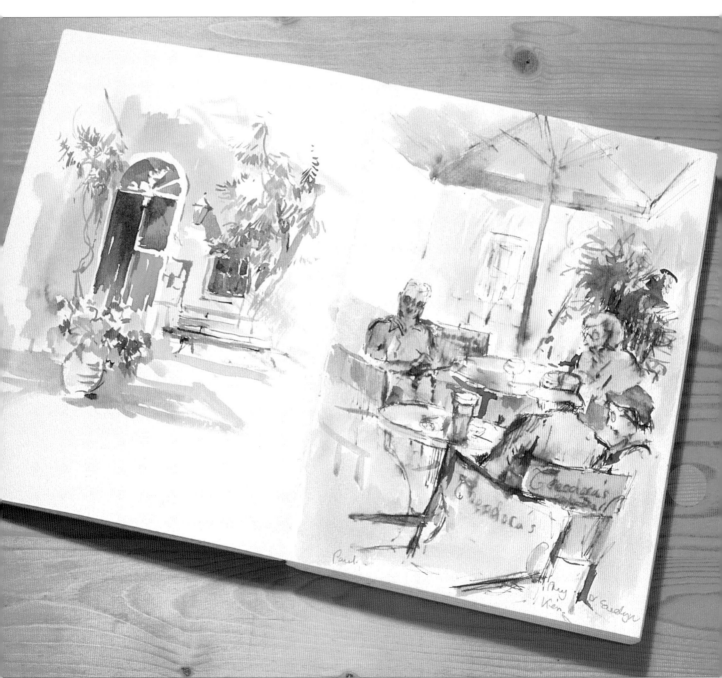

Paints

Acrylic paints are available in a large range of luscious colours, similar to that for watercolours and oils. They may be bought in tubes, pots or tubs. Buy the best quality you can afford. Acrylic paints cannot be reworked when they dry out, so replace caps and lids immediately after use.

Papers

Acrylics can be painted on to different types of paper and also on to many other, non-oily surfaces such as cardboard, canvas, wood and metal. However, I tend towards using sheets of watercolour paper or pads of purpose-made acrylic papers.

Watercolour papers are available with different surface finishes: Hot Pressed (HP) is smooth; NOT/Cold Pressed is slightly textured; and Rough is heavily textured. All these papers are made in a range of weights (thicknesses), from 190gsm (90lb) to 640gsm (300lb). I like to use a 300gsm (140lb) watercolour paper.

Acrylic papers and boards usually have a canvas-like finish, which gives good 'character' to the surface. You can buy pads of acrylic papers. These are excellent value, as they support the work and offer a range of surfaces to choose from – canvas, NOT and Rough.

Drawing board

A drawing board is useful for supporting individual sheets of paper. A 6mm (¼in) thick sheet of smooth plywood or MDF will prove ideal. Cut the board to suit your largest sheet of paper.

Brushes

The range of brushes available is vast, and selecting the right ones to use can be quite daunting. They come in many different shapes and sizes and vary in quality. To start with, I suggest you buy just one or two and then gradually build up a collection – again, buy the best you can afford. Brushes must always be kept very clean. At the end of a painting session wash them out in a strong soapy solution.

I use flat brushes (Nos. 8, 12 and 18), round brushes (Nos. 3, 4, 6 and 8) and two rigger brushes (Nos. 0 and 1).

Other items

Pencil I use a 6B graphite pencil for general sketching, and aquarelle pencils (which are also very soft) for quick colour notes.

Putty rubber This very soft eraser is ideal for removing initial pencil lines without marking the surface of the paper.

Easel I suggest using a lightweight, folding easel, which can be used in the studio or outside.

Impasto medium This can be added to acrylic paint to create heavy texture. A wide range of other mediums is available which includes varnishes and drying retarders – consult your art supplier for details.

Masking fluid I use this frequently and apply it with a **drawing pen** to save ruining my brushes. I usually add a little colour to clear masking fluid to make it more visible on the paper. Do not dilute the masking fluid too much or you will lose its 'removability'.

Masking tape I use this to secure my paper to the drawing board. You could also use clips.

Absorbent paper I use this to lift out colour from washes and to clean brushes. It also forms the wet reservoir in my stay-wet palette.

Water pots I use one pot to hold clean water for washes and another for rinsing out brushes.

Palette knife These come in a variety of shapes and sizes, and are used to apply acrylics as oils.

Colour Mixing

Colour mixing is one of the most important skills of a competent artist. Acrylic paints can be mixed with each other to create different colours, mixed with white to make paler tints, or diluted with water to create subtle, translucent tones. Learning how acrylics behave when diluted or mixed with each other takes a lot of practice, much like a piano student learning scales. There are no short cuts – you must carefully work up your skill in order to succeed. You could buy every available colour but, apart from the expense, you would still not be able to create the subtle tones that colour mixing can achieve. Here are some of the colour mixes I use for the paintings in this book.

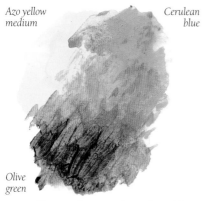

Azo yellow medium

Cerulean blue

Olive green

Azo yellow medium and cerulean blue make good 'safe' greens for foliage and trees. Mix them with a ready-made olive green to vary tonal values.

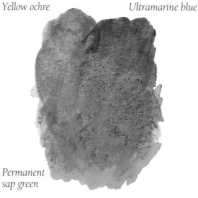

Yellow ochre

Ultramarine blue

Permanent sap green

Yellow ochre and ultramarine blue provide other tones of green. Introduce ready-made sap green to create even richer colours.

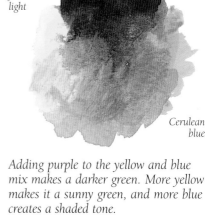

Cadmium yellow light

Dioxazine purple

Cerulean blue

Adding purple to the yellow and blue mix makes a darker green. More yellow makes it a sunny green, and more blue creates a shaded tone.

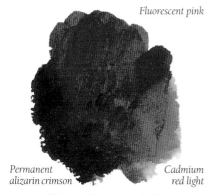

Fluorescent pink

Permanent alizarin crimson

Cadmium red light

Mixes of these colours are ideal for bright vibrant flowers such as geraniums. Use more crimson to give deeper, darker tones. Add more water or pink to create lighter, brighter effects.

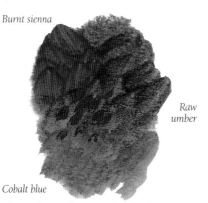

Burnt sienna

Raw umber

Cobalt blue

These three colours make shades that are ideal for rocks or tree bark. Use more burnt sienna for warm, light areas, and more raw umber and cobalt blue for deep, dark shadows.

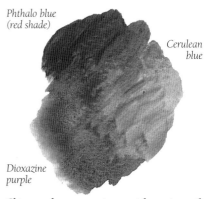

Phthalo blue (red shade)

Cerulean blue

Dioxazine purple

Skies and seas require a wide variety of colours and tones. This combination of colours will help to create a lot of them – use all three together for rich deep tones and mix them with titanium white for lighter tints.

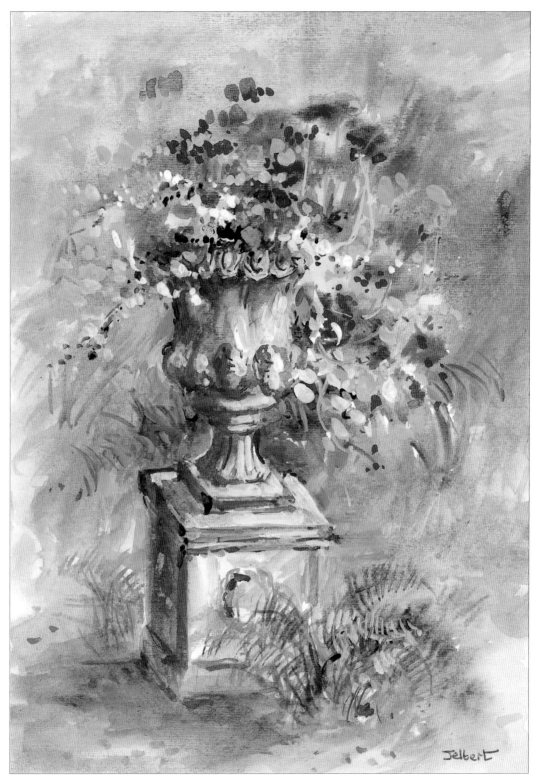

Geraniums in an Old Urn

175 x 255mm (6¾ x 10in)

This painting includes many of the colour combinations shown opposite.

Playing with acrylics

Painting with acrylics can be great fun as this medium is so versatile. You can use the colours in the same way as either watercolours or oils – so it offers many exciting challenges to the beginner and to the experienced artist.

Watercolour techniques

When used as watercolours, acrylics can be gentle and watery, bold and vibrant or wet into wet – in fact some of the so-called watercolour exhibitions in London comprise 75% acrylic paintings!

Acrylics also have the advantage that, when dry, the washes are so permanent that glazes can be added without the fear of disturbing the under-colours. If you need to change the colours, you can wash them off immediately, before drying, and start all over again without any change beneath.

Here are just a few of the watercolour techniques that can be worked with acrylics. The list is by no means complete and I am sure that, with a little experience, you will soon discover how to create many other different effects.

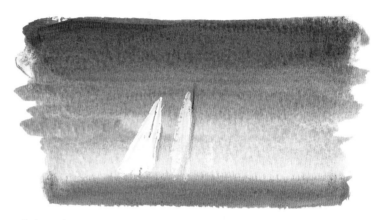

Simple graded wash

A graded wash is very suitable for a simple sky. Add water to blue acrylic to form a wash and then, using a large brush, lay a band of colour across the top of the paper. Add more water to the wash and lay another band of this tone slightly overlapping the first one. Continue adding more water and laying in more dilute colour to form a graded wash from dark to light. In this example, I stopped the wash on the horizon line and then laid in a band of strong colour for the sea. The sails were painted with neat titanium white.

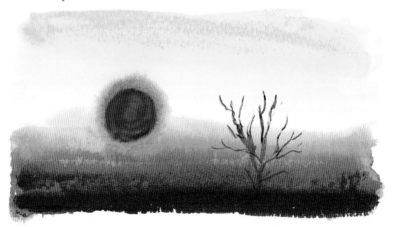

Blended washes

Blending two simple graded washes together can create some interesting effects. Lay in a simple graded wash in one colour, working from the top of the paper to the mid point. Turn the paper round and lay a contrasting wash down to the mid point, allowing the weakest tone of this colour to blend with the first wash. In this study of blended washes, the outer edge of the sun was painted while the washes were still damp. The paint was allowed to dry then the sun and tree were painted in.

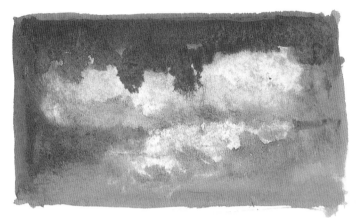

Lifting out

This technique can be used to create pale, soft-edged images such as clouds. Lay a wash on wetted paper and then press absorbent paper on to the wet paint to lift out some of the colour and create a lighter image in the paint. In this sky study I introduced greys into the bottom of the lifted-out clouds to create a more realistic effect.

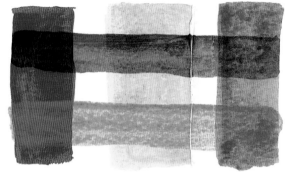

Glazes

Diluted acrylics are transparent and can be glazed over other dry colours to good effect. Experiment with bands of colour at right-angles to each other. Blue glazes are good for shadows, yellow ones for sunny studies.

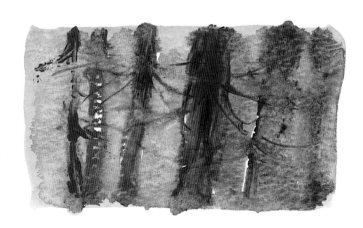

Wet into wet

This flower study of poppies started with a fusion of colours created by the wet-into-wet technique. Wet the paper with clean water and then drop diluted colours on to the wet surface. Tilt the paper from side to side and top to bottom, allowing the colours to blend together. This is a fascinating technique and with a little practice you will soon learn how to control paint flow.

Thick and thin wash

If you partly dilute the paint with water you create a wash containing blobs of neat colour, and this thick and thin mix can be used to create interesting effects. Dip a brush into the mix and skim it over the dry or wetted surface of the paper to create patches of deep colour on a wash of the same colour. In this tree study I first laid a blue wash over the paper and, while this was still damp, I painted the trees using the a thick and thin mix of brown.

Oil techniques

Acrylics may be used straight from the tube, using a palette knife or a brush, in a similar way to oil paints. Here are a few techniques for you to experiment with. Special mediums may be mixed with acrylic colours to retard the drying time and improve the flow. There are many mediums to choose from, so consult with your local art supplier.

Impasto

Impasto is the application of thick layers of paint straight from the tube using a brush or palette knife to create lovely textures. You can also mix paint with acrylic impasto medium to create much heavier patterning. Whichever method you use, the textures can be left as they are or, when they are completely dry, you can apply a glaze over parts of them. This is a lovely way to create designs on pots, or to reproduce the texture of old stone walls or steps.

Scumbling

Paint one colour on to a dry surface. When this is dry, use a brush or palette knife to drag another, quite stiff colour on top, letting the first colour 'gleam' through in places. This technique is useful for suggesting snow or rocks in a mountain scene.

Painting with a palette knife

Try painting a picture using just a palette knife and paint straight from the tube. Experiment with different blade shapes and adventurous strokes! These juicy, textured effects are ideal for architectural subjects but they can also be used for lots of other subjects. For example, here is a log fire with flames and smoke, painted entirely with a palette knife.

Other techniques

Here are two other techniques for you to experiment with. Masking fluid creates controlled highlights, and can be combined with any of the painting techniques discussed on the previous pages. The random lifting out technique, which can only be worked with acrylic paint, creates an exciting and free start to a painting.

These 'tricks-of-the-trade' are fun to play with, they will enhance your work and they offer you a variety of ways to paint many different subjects. Hopefully, they will fire up your imagination to paint even more diverse subject matter.

Using masking fluid

Masking fluid repels paint so it can be used to retain areas of white paper. Alternatively, it can be applied on to dry painted areas that are to be overpainted with, say, a glaze. Apply the masking fluid with a drawing pen or an old brush and allow it to dry. Paint over it and then, when all the paint is dry, rub off the masking fluid to expose the white paper or under-colour. Do not apply too heavy a layer of paint on the masking fluid, as this may make it difficult to remove. Use masking fluid for images such as the trees shown here, or for small details of plants or architectural features.

Random lifting out

This technique relies on the fact that although acrylic paint is diluted with water, it becomes waterproof when dry. This characteristic can be used to create some exciting, uncontrolled results. Apply different thicknesses of paint to the paper, partly dry the surface (with a hairdryer), then submerge the paper in a bowl of clean water and rub the painted surface with your fingers. Some of the still-wet colour will lift off and leave plain paper (or muted colours) in random patterns.

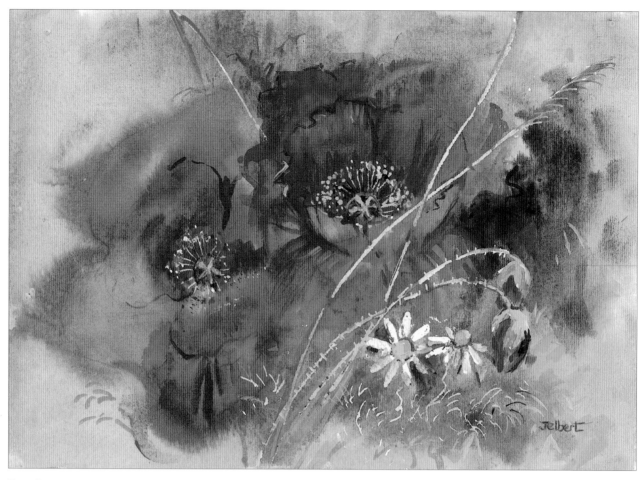

Poppies
255 x 180mm (10 x 7in)

Poppies are one of the most popular subjects to paint. They are so perfect for watercolour techniques, as they ebb and flow into each other and the surrounding areas.

I sketched in the poppy heads, daisies, buds and stalks with a pencil, then applied coloured masking fluid with a drawing pen.

When the masking fluid was dry, I wetted the paper and painted around the flower heads using a light green mixture of yellow ochre and olive green. While this was still wet, I quickly painted in the flowers using tones of red and pink, letting the colours mix on the paper. I added dark accents with blues and greens to the right of the poppies and seed heads. When the paint was thoroughly dry, I carefully rubbed off the masking fluid.

I intensified the darks in the background, detailed the seed heads with yellow ochre and olive green and painted in the buds and daisies with a rigger. Finally, I washed over some of the white daisy petals with pale blue tones, and allowed others to remain light.

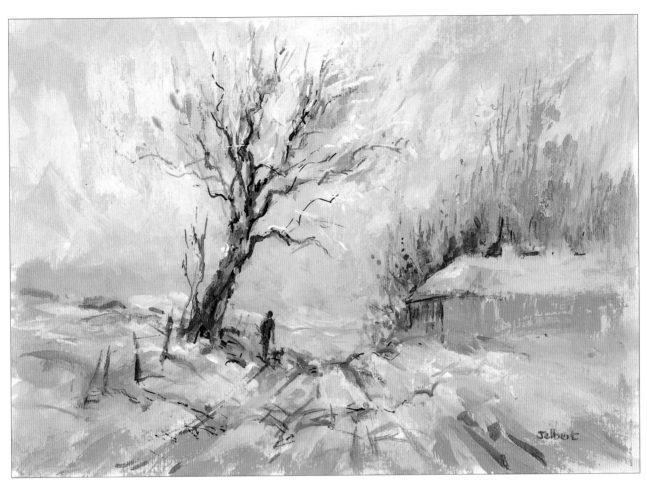

Snow scene
255 x 180mm (10 x 7in)

This simple landscape composition is painted quite loosely, using relatively dry mixes of acrylic paint as oils.

I used a rigger brush and raw umber to sketch in the tree, path and house. When these marks had dried, I covered the whole surface with a watery covering of yellow ochre as an undercoat to unite all the elements of the painting.

I applied a mix of cobalt blue and titanium white to the sky and distant trees, and used a slightly lighter mix for the roof. I used dioxazine purple and titanium white in the foreground and in the shadowed areas under the tree and across the path.

The sky, distant trees and foreground areas were completed using thick layers of blues and purples, allowing small chinks of the original yellow ochre to show through and add sparkle. I painted in the house, pulling colour into the surrounding area of snow and across the path to the tree. I then used the palette knife to thicken the snow with small dabs of lighter blues.

Details of the tree and fence posts were added using a rigger brush with burnt sienna and blues. Finally, I painted in the figure and dog as a focal point.

Painting skies

Skies can be magical, and I love to just sit and watch the ever-changing shapes and colours. Even a cloudless blue sky will change through the course of the day. For a landscape to be successful, the sky should be painted in sympathy with the surroundings below – choose a simple sky if the main subject is full of detail. On these pages I show you three skies, each painted using a different technique.

Simple sky – graded wash

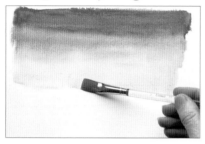

1. Dampen the paper with clean water. Then, working with long horizontal strokes of a large flat brush, lay in a graded wash of ultramarine blue. Work down the paper, laying in more dilute tones towards the horizon.

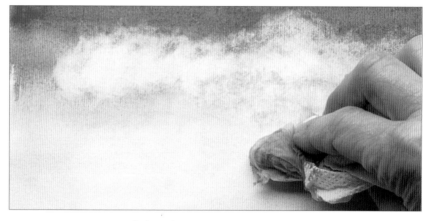

2. Dampen a piece of absorbent paper and gently dab out some clouds. Work quickly, using a clean part of the paper each time you lift out the colour.

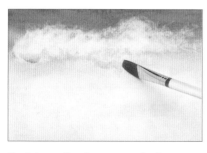

3. Mix a fluid grey wash from ultramarine blue and a touch of burnt sienna, and then paint shadowed areas into the undersides of the clouds.

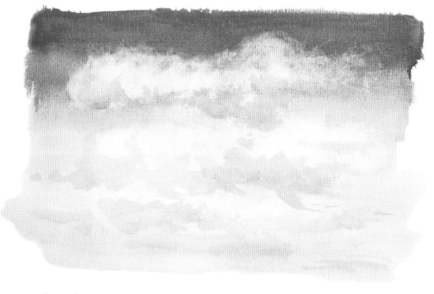

4. Dilute the grey mix slightly, then paint in the edges of the more distant clouds to complete the sky.

Sunset – wet into wet

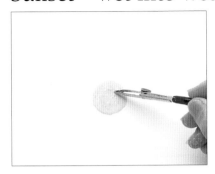

1. Use masking fluid and a drawing pen to create a rough circular shape for the sun. Leave to dry.

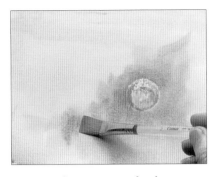

2. Wet the paper with clean water. Mix azo yellow medium with cadmium red light and lay an orange wash across the paper. Add a touch of fluorescent pink to the mix and wash this around the sun, allowing the edges to blend with the still-damp yellow.

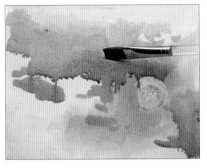

3. Use a wash of dioxazine purple to lay in some clouds around the sun. Add touches of ultramarine blue, dioxazine purple and clean water to the clouds to create shape and form.

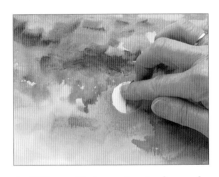

4. When all the paint is dry, rub off the masking fluid to reveal white paper.

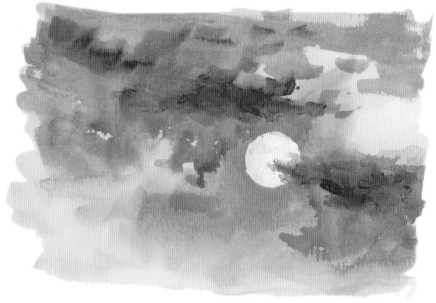

5. Now use diluted azo yellow medium to paint the sun, weakening the colour as you work across the shape. Use dioxazine purple to lay a few wisps of cloud across the sun.

Stormy sky – oil technique

1. Using various strengths of colour, 'flick' yellow ochre in all directions over the paper. Leave to dry.

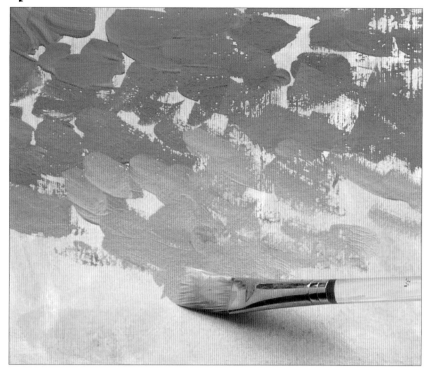

2. Mix a mid blue from ultramarine blue and titanium white. Dab this colour over the yellow, leaving some of the yellow to peep through. Add more white to the blue mix as you work down the paper, and gradually introduce softer strokes of the brush.

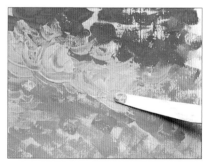

3. Add touches of burnt sienna and ultramarine blue to titanium white, then use a palette knife to lay in some clouds; use the blade to create swirls and texture.

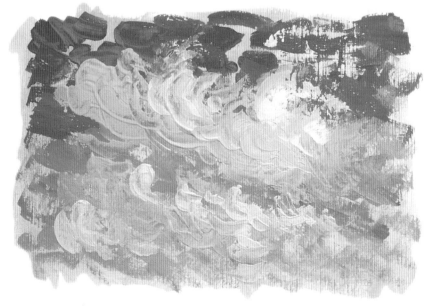

4. Finally, add highlights in the clouds using titanium white with a hint of burnt sienna.

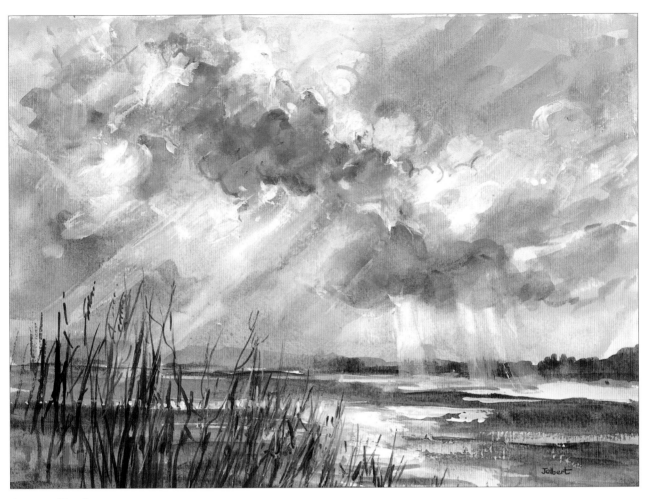

Stormy Clouds

340 x 245mm (13½ x 9¾in)

This dramatic sky painting captures the feel of a stormy yet sunny day. The sun rays bursting through gaps in the menacing clouds highlight the middle distance. This light area provides a stark contrast between the dark background and the silhouetted detail of the foreground foliage.

Daisies on a cliff top

I look on paintings as 'visual poetry', so their composition deserves consideration and thought! It is advisable to develop a mental 'clipboard' of key points to remember. You should ask yourself several questions. Why have I chosen this scene? What do I like about it? Where is my focal point? Do I need to vary the composition? What colours do I need? As you can see, there are quite a lot of questions that have to be answered before starting to paint the picture.

Ideally the focal point should be slightly off centre, both horizontally and vertically – about one-third in from one side of the paper, and one-third up or down from the bottom or top of the paper. This point should contain the lightest, darkest, most detailed or most colourful part of your painting.

Drawing sketches before you start to paint can help iron out any problems with composition. I came across this attractive scene whilst on a cliff-top walk and decided to sketch it for future reference. I made several sketches, varying the viewpoint slightly on each one, until I was happy with the composition. Some of these sketches, including the one I chose to use for this demonstration, are shown here.

I painted the picture on a 405 x 305mm (16 x 12in) sheet of 300gsm (140lb) watercolour paper. I used masking fluid on the foreground flowers and grasses, and blocked in the background colours using the graded wash, blended wash and wet-into-wet techniques.

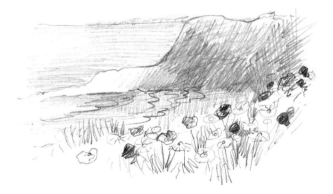

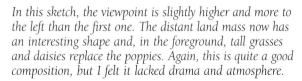

On this, my initial sketch, I marked in the different tones that I could see from my vantage point, and indicated the angles and slopes of the headlands. I then roughed in the poppies and grasses in the foreground. This is a reasonable composition, with lots of foreground detail, some interesting middle distance shapes and textures, but a rather flat horizon.

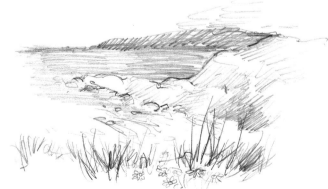

In this sketch, the viewpoint is slightly higher and more to the left than the first one. The distant land mass now has an interesting shape and, in the foreground, tall grasses and daisies replace the poppies. Again, this is quite a good composition, but I felt it lacked drama and atmosphere.

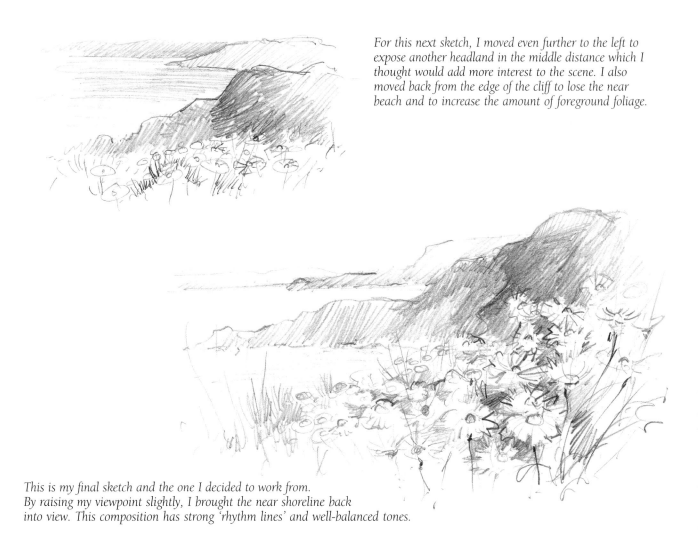

For this next sketch, I moved even further to the left to expose another headland in the middle distance which I thought would add more interest to the scene. I also moved back from the edge of the cliff to lose the near beach and to increase the amount of foreground foliage.

This is my final sketch and the one I decided to work from. By raising my viewpoint slightly, I brought the near shoreline back into view. This composition has strong 'rhythm lines' and well-balanced tones.

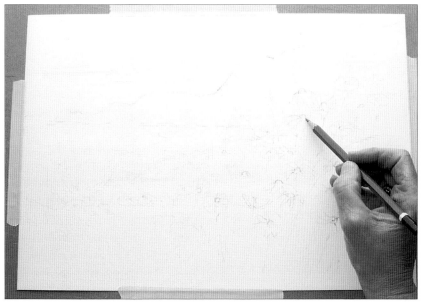

1. Use a 2B pencil to lightly draw in the main elements of the composition.

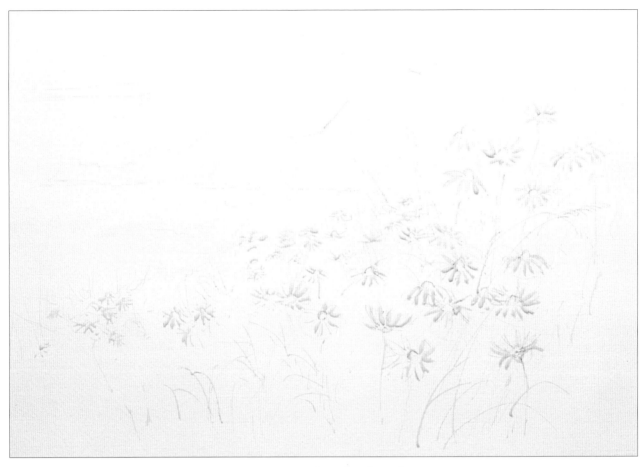

2. Use a drawing pen to apply masking fluid to the daisy heads and some of the flower stems and grasses.

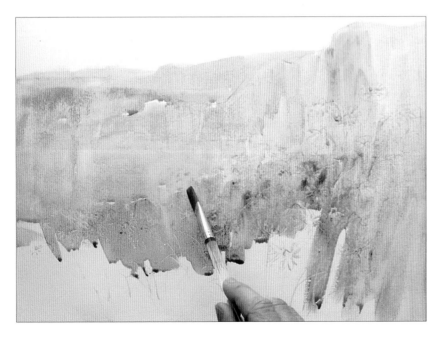

3. Use the flat brush to wet the paper with clean water and then quickly wash colour all over it. Wash the middle-distant headland with yellow ochre. Paint the distant headland with very dilute ultramarine blue, add a touch of dioxazine purple and lay in the far headland. Lay ultramarine blue into the sea. Paint the foreground area with burnt sienna and then run in some phthalo green (blue shade). Allow all the colours to run into each other. Finally lay a weak wash of ultramarine blue into the sky area. Leave to dry.

4. Mix a dilute wash of olive green with a touch of burnt sienna then, starting from the right-hand side, glaze this over the foreground. Darken the wash with ultramarine blue and use the edge of the brush to create blades of grass.

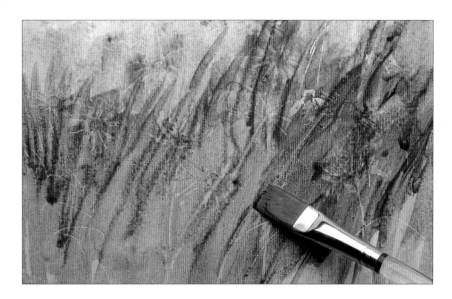

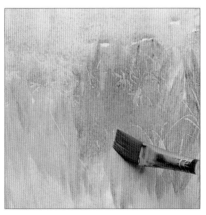

5. Add more ultramarine blue, then paint the left-hand side of the foreground, fading the colour towards the edge of the picture.

6. Mix raw umber with burnt sienna and use broad vertical strokes of the brush to add some darks to the middle-distant headland. Pull the colour down across the foreground daisy heads.

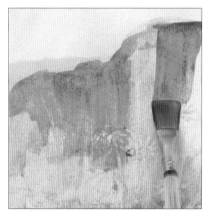

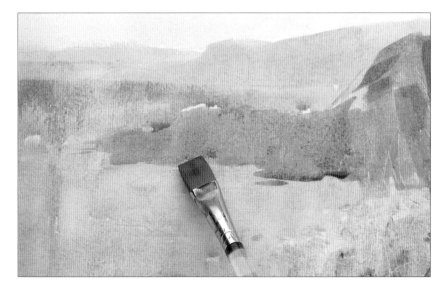

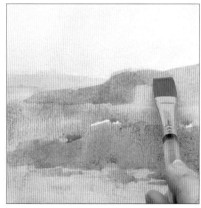

8. Add a glaze of dioxazine purple, slightly warmer than the first, to the distant headland.

7. Continue painting in the headland with burnt sienna, then add ultramarine blue to push the rocky outcrop back slightly.

9. Use a mix of dioxazine purple, burnt sienna and ultramarine blue to work shadows into the near cliffs – bring the colour down over the top of the daisies.

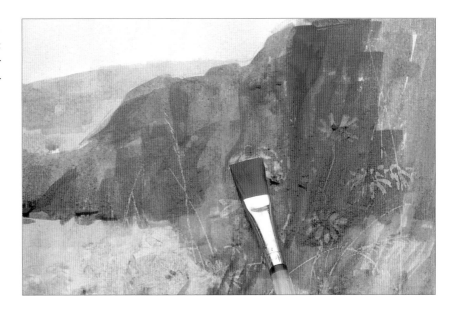

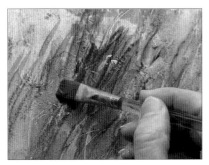

10. Use a mix of olive green and burnt sienna to intensify the foreground grasses.

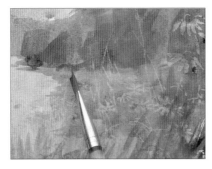

11. Wash dioxazine purple into the near beach area, varying the tone to create depth. Leave the painting to dry.

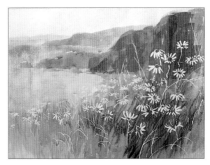

12. Gently rub away the masking fluid to reveal the white paper under the daisies and grasses.

13. Use a rigger brush to block in the yellow flower centres – paint some with yellow ochre and others with azo yellow medium. Vary the tones to create shape, then add touches of burnt sienna as shadows.

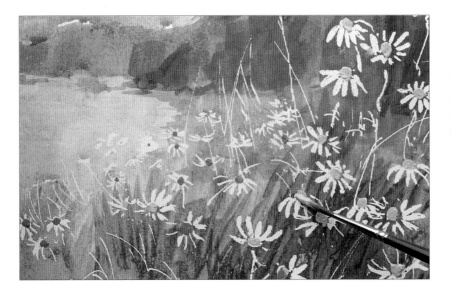

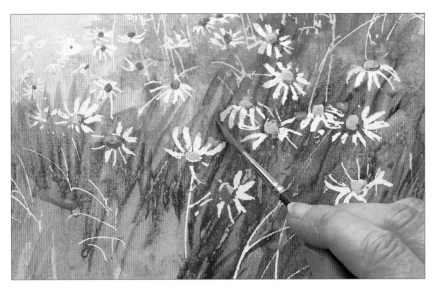

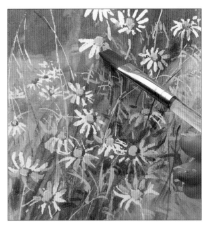

14. Mix a dilute wash of the background tones with phthalo green (blue shade) and azo yellow medium and use the flat brush to glaze over the white grasses left by the masking fluid. Use the rigger brush to add more grassy spikes in various tones of green. Leave to dry.

15. Mix a weak wash of dioxazine purple and ultramarine blue and use the flat brush to lay this over the daisy petals. Finally, use clean damp absorbent paper to lift out some of the colour to create shape and highlights.

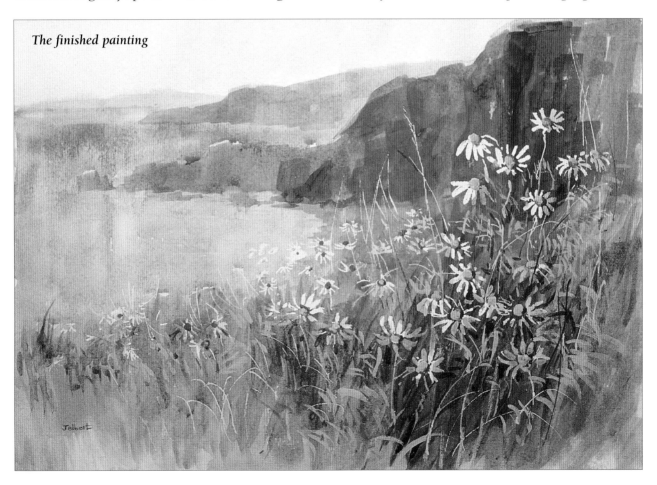

The finished painting

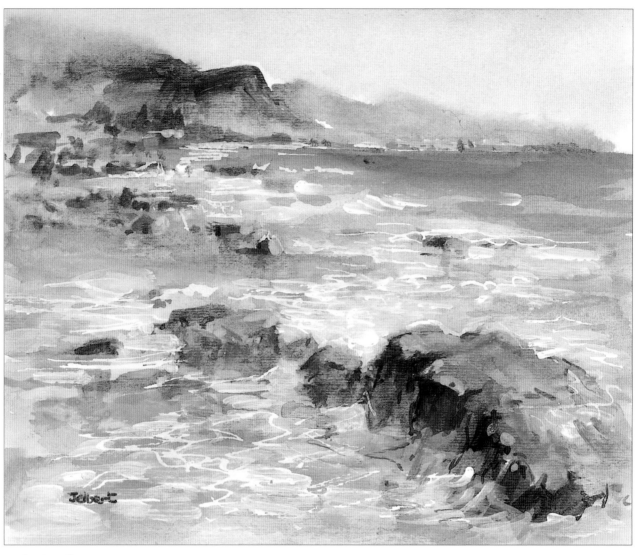

Rocky Sea Shore
175 x 145mm (6¾ x 5¾in)

This typical Cornish sea scene includes a gorgeous contrast of tone between the rocks, sea and sky. I used masking fluid to create the highlights in the waves and a palette knife to work texture into the rocks

Opposite
Sand Dunes
175 x 225mm (6¾ x 8¾in)
I painted this scene because I liked the way the light sea area was cradled between the foreground grasses and dunes and the distant headland, creating a contrast of tone and texture.

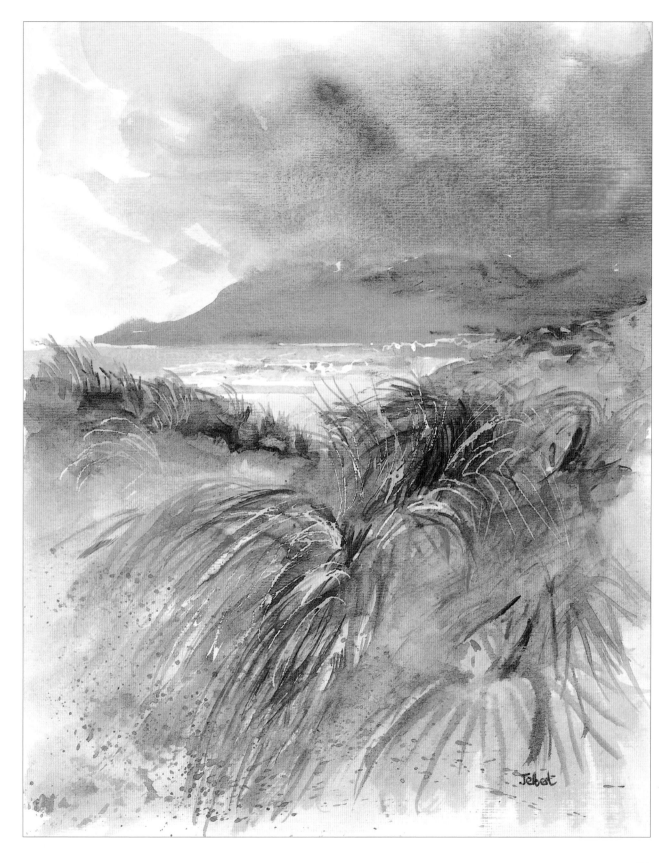

Sunlit window

I came across this colourful wall whilst on a painting holiday in Brittany with some of my students. I made a pencil sketch composition, and I also took a few photographs to remind me of the colours and textures. The impasto technique is excellent for depicting the texture of the rough stone wall and, for this demonstration, I also use glazing and scumbling to reproduce the colours of the stonework. Masking fluid helps accentuate the highlights, whilst the wet-into-wet technique is perfect for depicting the riotous colours of the geraniums. I painted this picture on a 405 x 305mm (16 x 12in) sheet of 300gsm (140lb) paper.

You will need
Titanium white
Burnt sienna
Raw umber
Payne's gray
Dioxazine purple
Cadmium orange
Azo yellow medium
Permanent sap green
Olive green
Fluorescent pink
Ultramarine blue
Yellow ochre
2B pencil
Masking fluid and a drawing pen
Palette knife
No. 10 flat brush
No. 6 round brush

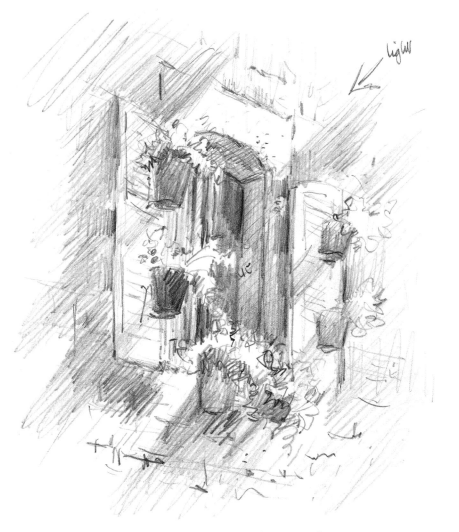

Pencil sketch drawn on location. Compare this 'squared-up' composition with the distorted image of the photographic reference.

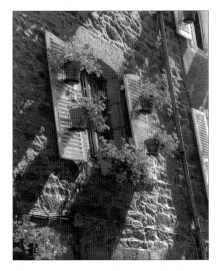

Photographs are useful as reminders of colour and texture. However, they often show lots of extraneous detail and can have peculiar perspectives. This one, for example, was taken in a narrow lane and I could not move back far enough to get the uprights vertical.

1. Use a 2B pencil to lightly draw in the main elements of the composition. Then, using masking fluid (mixed with a touch of colour) and a drawing pen, mask out some of the mortar and the louvres on the window shutters.

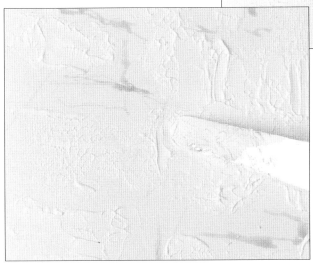

2. Use a palette knife and titanium white straight from the tube to apply paint to the stone wall. Work short horizontal and vertical strokes to create different textures. Leave to dry.

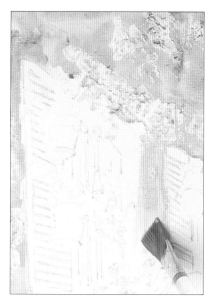

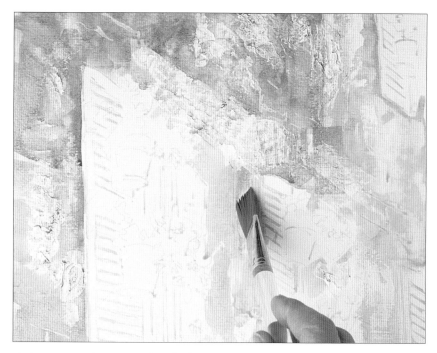

3. Use the flat brush to lay a wash of burnt sienna and raw umber over the stone walls. Leave to dry.

4. Mix Payne's gray with a little titanium white, then glaze over all the stonework (except the lintels) to vary the tone. Allow the colour to concentrate in the deep recesses of the impasto texture.

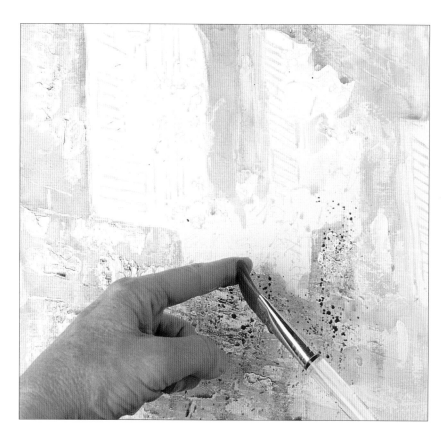

5. Mix a very wet wash of dioxazine purple and raw umber, then drag your finger across the brush to splatter the paint randomly over the painted stonework.

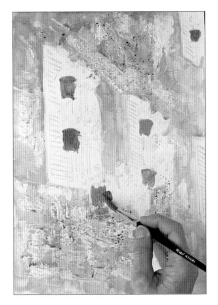

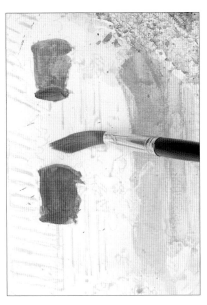

6. Mix burnt sienna with cadmium orange, then use the round brush to paint in the flower pots in various tones. Add touches of raw umber to create shadows and shape.

7. Re-wet the areas of foliage.

8. Paint azo yellow medium, wet into wet, into areas of foliage, then drop in some permanent sap green.

9. Add a few touches of olive green to the foliage to create shape, then drop in fluorescent pink for the flower heads.

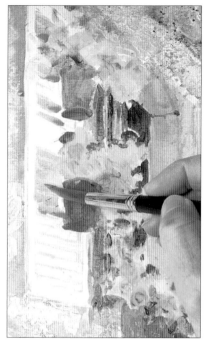

10. Block in the dark windows, using a mix of ultramarine blue, azo yellow medium and a touch of permanent sap green.

11. Use dioxazine purple to create deeper shadows in the windows and define the outline of the foliage.

12. Start to define the window shutters by painting the louvres with a mix of ultramarine blue and a touch of permanent sap green. Leave to dry.

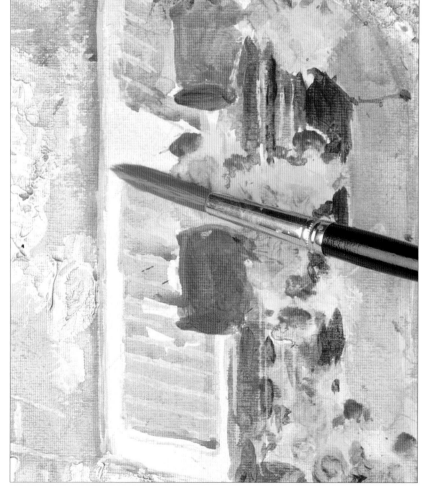

13. Now apply a weak yellow ochre glaze over the window shutters.

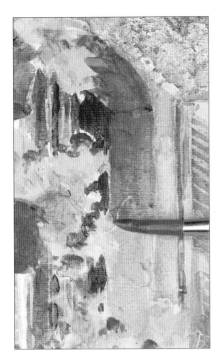

14. Add more colour to the window reveals using a mix of burnt sienna with a touch of yellow ochre. Vary the tone to create shape and shadows. Leave to dry.

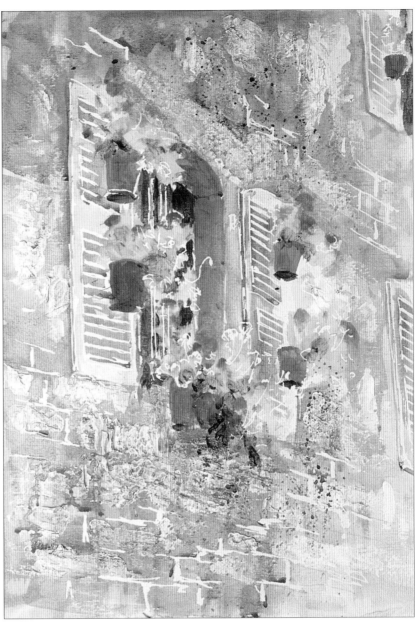

15. Carefully rub off all the masking fluid.

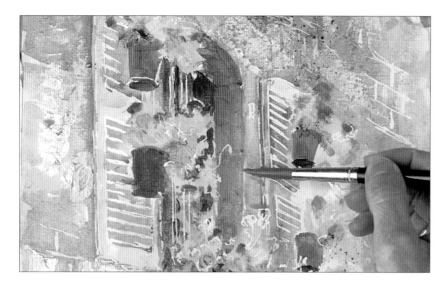

16. Glaze diluted washes of the background tones over the stonework, foliage and flowers to soften all the exposed areas of white paper.

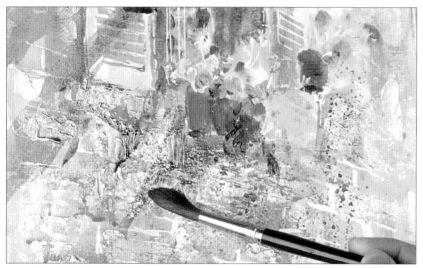

17. Mix dioxazine purple with ultramarine blue and a touch of burnt sienna, then add shadows across the walls, shutters, flower pots and foliage. Leave to dry.

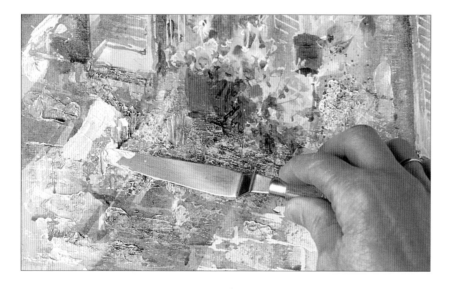

18. Finally, mix titanium white and yellow ochre straight from the tube, then use a palette knife to scumble a thin layer of colour over the sunlit areas of stonework.

Opposite
The finished painting

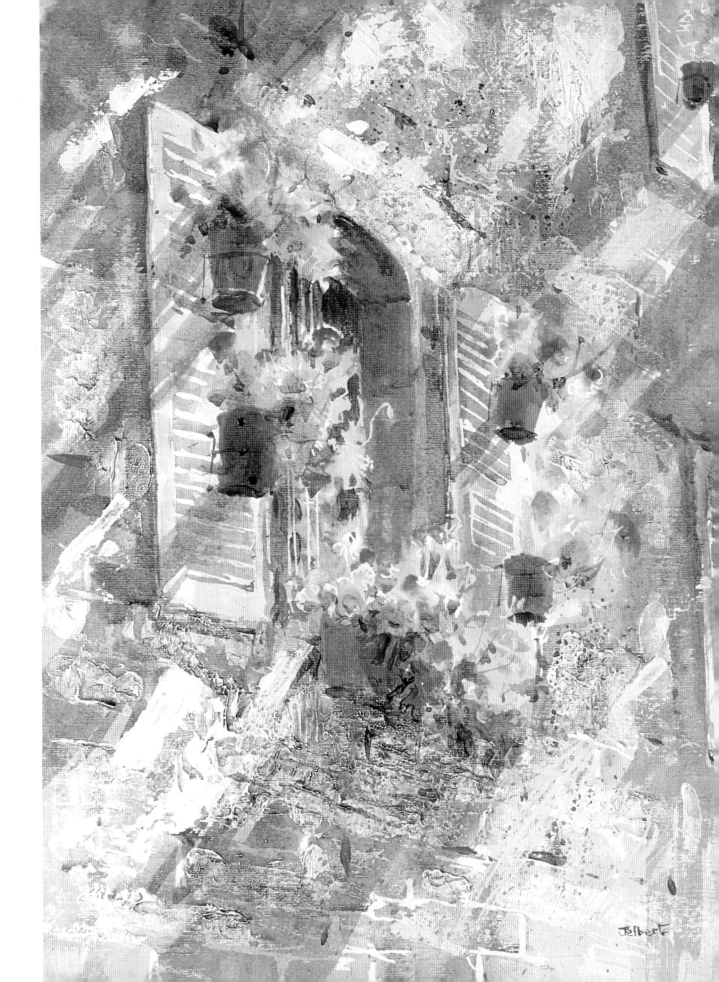

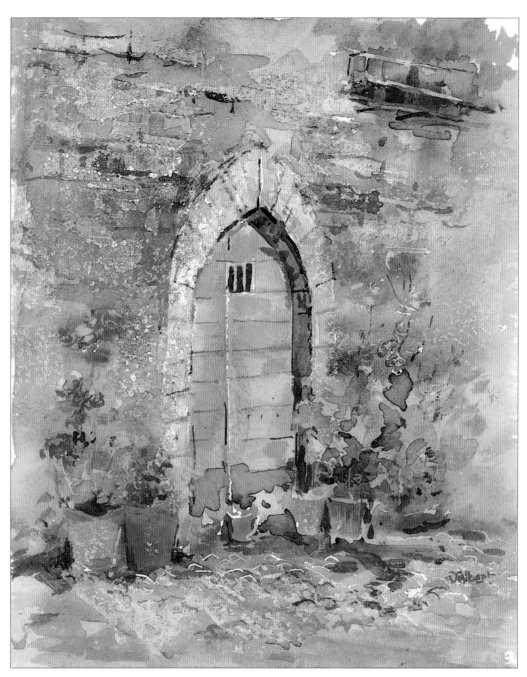

Tuscany Door with Flowers
155 x 185mm (6 x 7¼in)

I used the impasto texturing technique described on page 33 to produce the weathered appearance of these old walls. The light blue of the door contrasts well against the greys, burnt sienna and yellow ochre tones used for the stonework.

Opposite
Greek Doorway with Old Chair
370 x 495mm (14½ x 19½in)

The atmosphere of this painting is created by the contrast between the light and dark areas. I loved the sunlit vines, the reflected light on the old chair and the foreground thistles, all of which were painted with masking fluid at an early stage. I also used an assortment of different textures when painting the walls and foreground areas.

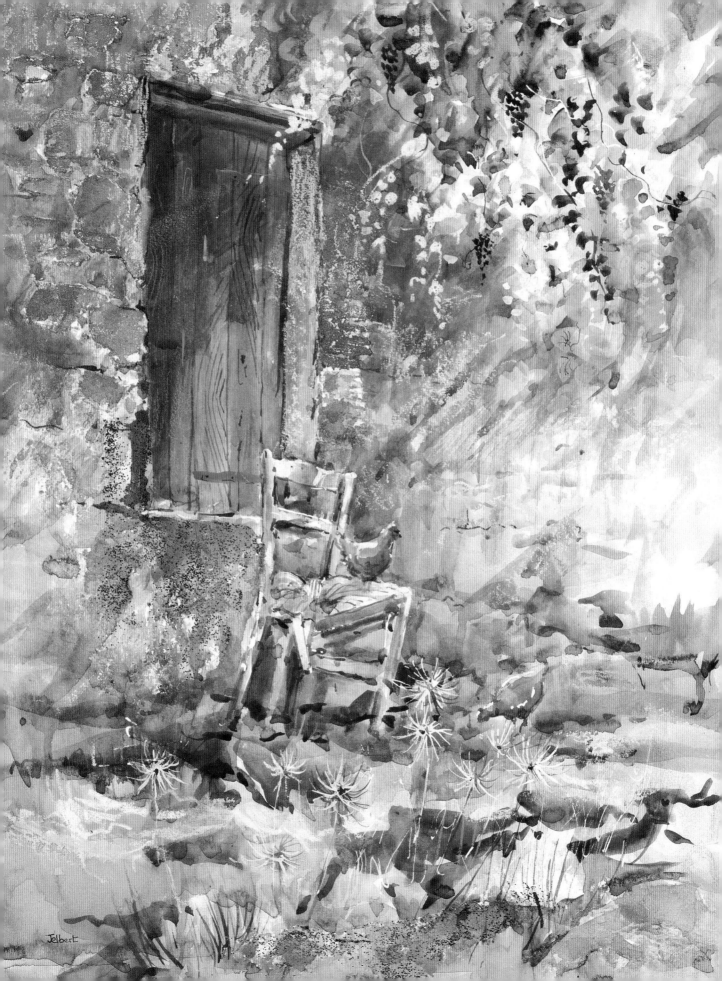

Jelbert

Farmyard

I love painting animals in general, and chickens in particular. I used two reference photographs to compose this painting – one of a roadside fence, the other of a group of chickens.

In this demonstration I use simple washes, controlled and random lifting out, impasto, thick and thin, glazing and scumbling techniques. The picture is painted on a 405 x 305mm (16 x 12in) sheet of 300gsm (140lb) watercolour paper.

<table>
<tr><td>

You will need
Cerulean blue
Ultramarine blue
Permanent sap green
Olive green
Burnt sienna
Yellow ochre
Dioxazine purple
Azo yellow medium
Cadmium red light
Titanium white
Impasto medium
2B pencil
No. 10 Flat brush
No. 6 Round brush
No. 1 Rigger brush
Palette knives
Absorbent paper
Washing-up bowl
Masking tape

</td></tr>
</table>

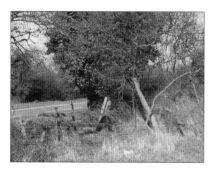 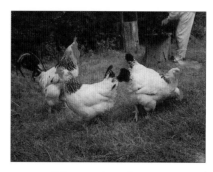

The two photographs used to compose the painting. When working from photographs, I usually sketch the outlines straight on to the painting paper. However, I have also included a pencil sketch to show you how I combined details from each photograph to form the final composition.

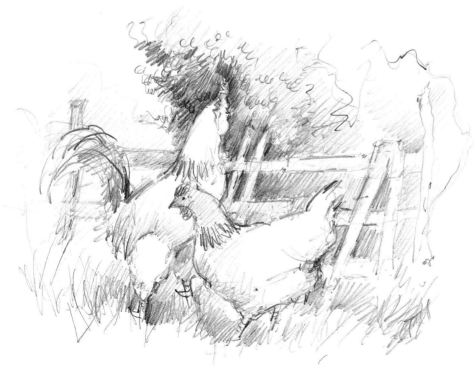

1. Use a 2B pencil to draw the outlines of the main elements on to your paper.

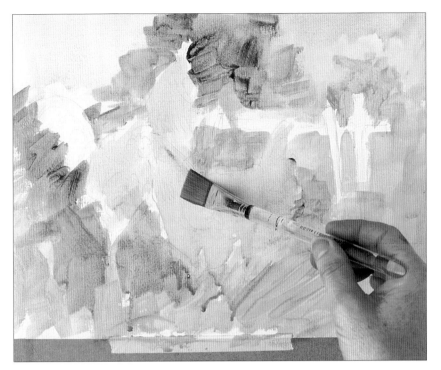

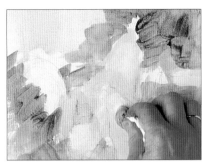

3. While the paint is still damp, lift out some colour from the hen using damp absorbent paper.

2. Use the flat brush to lay a pale wash of cerulean blue over the sky and chickens, then lay a pale wash of ultramarine blue mixed with permanent sap green over the foliage. Add more blue and some olive green to the mix, then block in the foliage around the cockerel. Use the thick and thin technique to brush ultramarine blue over both chickens.

4. Reinstate the dark areas using the flat brush with mixes of olive green and ultramarine blue.

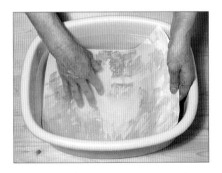

5. Allow the painting to partly dry, then immerse the paper in a bowl of clean water. Rub the surface of the painting gently, so that the image breaks up slightly.

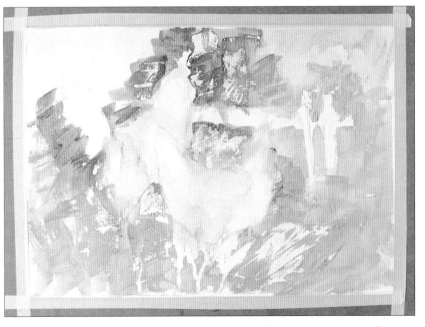

6. Secure the wet paper to the drawing board with long strips of masking tape, then allow the paper to dry on a flat surface.

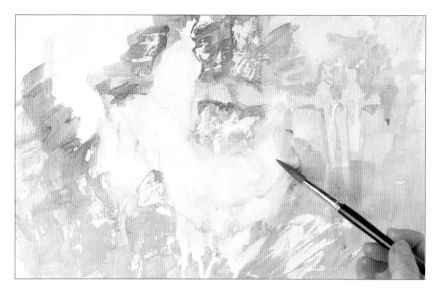

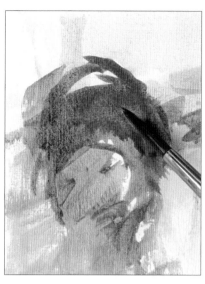

7. Mix yellow ochre, burnt sienna and a touch of ultramarine blue, then use the round brush to wash in the fence. Add touches of the same colour to the chickens to define form.

8. Paint in the cockerel's tail feathers using mixes of dioxazine purple and ultramarine blue.

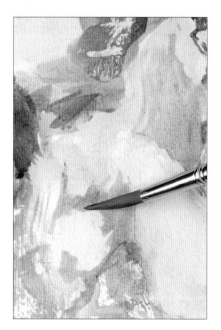

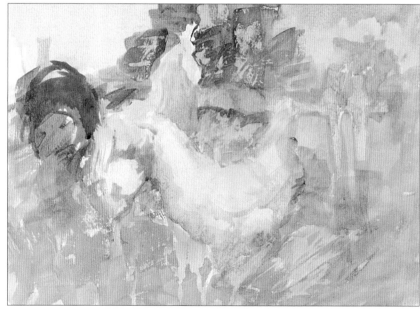

9. Dilute the mix and define the cockerel's neck feathers and legs.

10. Work up the shape of the hen in a similar way to the cockerel with a dilute wash of cerulean blue. Then, using azo yellow medium and the flat brush, glaze across the grass and foliage to colour any remaining white areas.

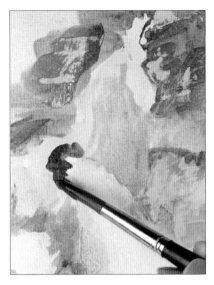

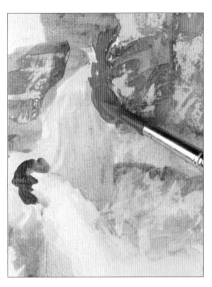

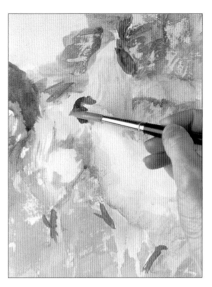

11. Mix cadmium red light, burnt sienna and a touch of dioxazine purple, then paint in the hen's comb and wattle.

12. Mix cadmium red light with some azo yellow medium to make a brighter red, then paint in the cockerel's comb and wattle.

13. Paint the chickens' legs with the two red mixes, then add shadow and form to their heads. Paint the beaks with yellow ochre.

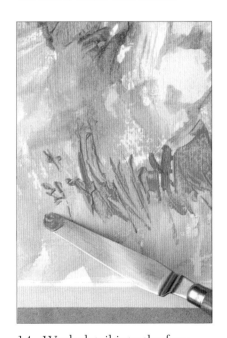

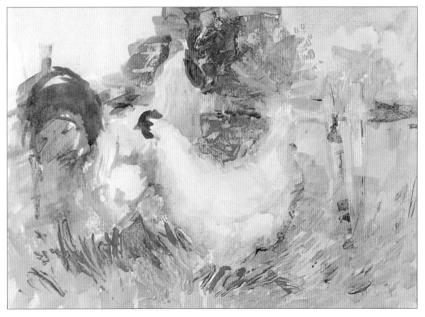

14. Work detail into the foreground grasses and foliage using a palette knife and a dry mix of permanent sap green with a touch of olive green.

15. Add touches of cerulean blue and titanium white to the green mix, then continue to develop the grass using variations of tone and different strokes of the palette knife. Mix permanent sap green with dioxazine purple and burnt sienna, then scumble this colour over parts of the fence to create shadows and the appearance of age.

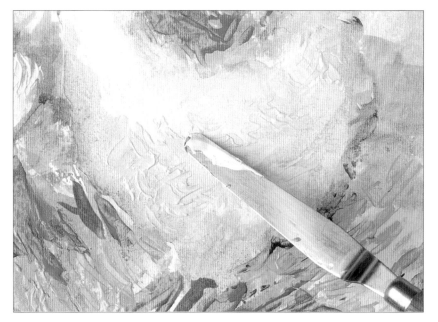

16. Mix cerulean blue, titanium white and impasto medium, then create feathers with a palette knife to 'fatten up' the chickens

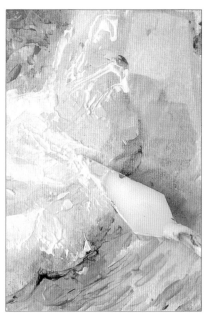

17. Mix a touch of impasto medium with titanium white, then add highlights on the feathers. Use a pointed palette knife to add fine detail.

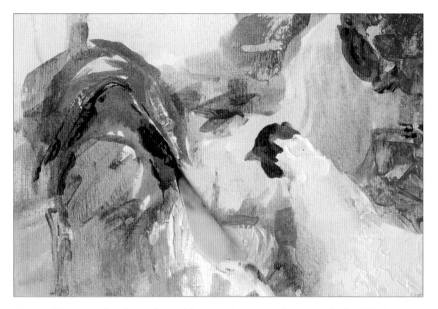

18. Add a touch of cerulean blue to the mix, then apply highlights to the cockerel's tail feathers. Now add dioxazine purple to the mix and define some darker feathers. Use the same mix to define a few dark areas on the bodies of both chickens.

19. Use a palette knife and a mix of ultramarine blue and olive green to add definition to the hen's tail feathers. Use the same mix and the round brush to define the eyes of both birds.

20. Mix a grey from burnt sienna and cerulean blue, then use crisscross strokes of a rigger brush to paint in the cockerel's neck feathers. Make a darker mix and add more brush strokes to define shape, and to create a dark area behind the hen's head. Mix burnt sienna with a touch of ultramarine blue, then work the hen's neck feathers in the same way.

The finished painting

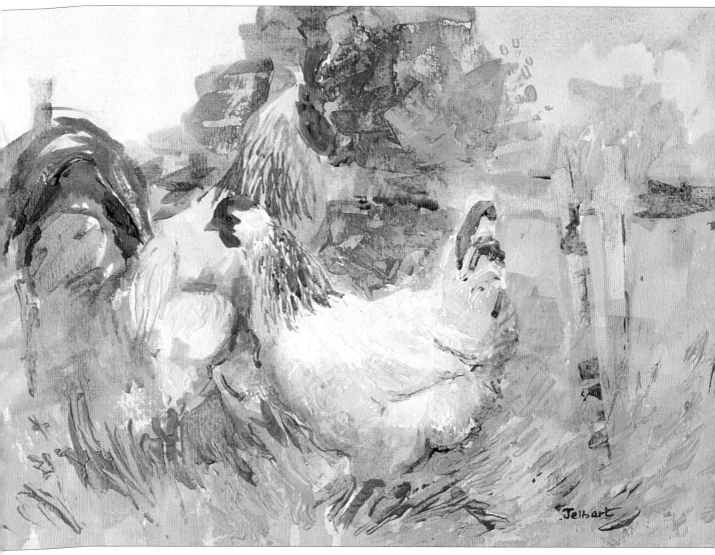

Index

brushes 11

chickens 42-47
cliffs 24–29
clouds 15, 20–23
colour mixing 12
composition 24–25, 32, 42

daisies 18, 24–29,

focal point 19, 24
foliage 23, 24–29, 35–36, 38, 44, 45

geraniums 13, 32, 35
glazes 15, 16, 17, 27, 29, 32, 34, 36
 38, 42, 44
grass 24, 27–29, 30, 44, 45

highlights 17, 22, 23, 29, 30, 32, 46

impasto 6, 11, 16, 32, 33, 40, 42, 46

lifting out 15, 20, 29, 42, 43
 random 17, 42, 43

masking fluid 11, 17, 18, 21, 24, 26,
 28, 30, 32, 33, 37, 40
painting surfaces 6, 10
paints 10
palette knives 11
 painting with 16, 19, 22, 30, 33,
 38, 45, 46
palettes 6, 8
papers 10
photographs, using 32, 42
poppies 15, 18, 24

scumbling 16, 32, 38, 42, 45
sea 7, 14, 26, 30
shadows 15, 19, 20, 28, 35, 36, 37,
 38, 45
shells 6
sketchbook 9
sketching 9, 24–25, 32, 42
skies 14, 15, 19, 20–23, 30

snow 16, 19
stonework 32-38, 40
sun 14, 21, 23

techniques
 oil 16, 22 see also palette knives,
 painting with; impasto; scumbling
 other 17 see also masking fluid;
 lifting out, random
 watercolour 14–15 see also washes;
 lifting out; glazes; wet into wet
texture 6, 11, 16, 24, 30, 31, 33, 40
trees 14, 15, 17, 19

walls 16, 32–38, 40
washes 18, 20, 26–29, 34, 38, 43–
 44
 blended 14, 21, 24
 graded 6, 14, 20, 24
 thick and thin 15, 42, 43
wet into wet 15, 18, 21, 24, 32, 35

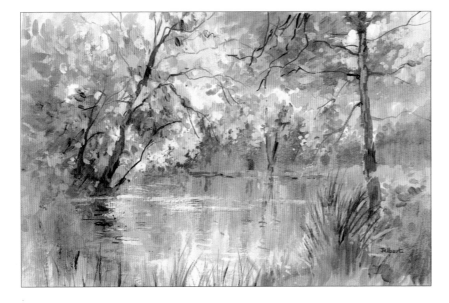

Riverside Peace
355 x 230mm (14 x 9in)

This tranquil setting, on the bank of a river near my home, seemed an ideal subject for the last painting in this book. I mixed many of my favourite colours with ready-made greens such as permanent sap green, to produce a wide assortment of lovely green tones: dioxazine purple and olive green for the deep shades; cerulean blue for the shaded areas; burnt sienna for the mid shades; and yellow ochre and azo yellow medium for the sunny shades. The radiant light captured in this painting is achieved by contrasting light tones against dark ones, in both the trees and water.